the

ULTIMATE

Brush lettering

GUIDE

the ULTIMATE Brush Lettering Guide

A COMPLETE STEP-BY-STEP CREATIVE WORKBOOK
TO JUMP-START MODERN CALLIGRAPHY SKILLS

PEGGY DEAN

WATSON · GUPTILL
CALIFORNIA | NEW YORK

Published in the United States by Watson-Guptill
Publications, an imprint of the Crown Publishing Group,
a division of Penguin Random House LLC, New York.
www.crownpublishing.com
www.watsonguptill.com

WATSON-GUPTILL and the HORSE HEAD colophon are
registered trademarks of Penguin Random House LLC.

Originally published in the United States by The Pigeon
Letters, in 2017.

Library of Congress Cataloging-in-Publication Data
Title: The ultimate brush lettering guide: a complete
 step-by-step creative workbook to jump-start modern
 calligraphy skills / Peggy Dean.
Description: California | New York: Watson-Guptill, 2018. |
 Includes index.
Identifiers: LCCN 2018002117
Subjects: LCSH: Lettering. | Alphabets. | BISAC: ART /
 Techniques / Calligraphy. | ART / Techniques / Pen &
 Ink Drawing. | SELF-HELP / Creativity.
Classification: LCC NK3600 .D36 2018 | DDC
 769.5—dc23
LC record available at https://lccn.loc.gov/2018002117

Trade Paperback ISBN: 978-0-399-58217-2
eBook ISBN: 978-0-399-58218-9

Printed in the United States of America

Design by Debbie Berne

10 9 8 7 6 5 4 3 2 1

First Edition

Dedicated to Laura.
Thank you for believing in my journey
before I even knew I had one.

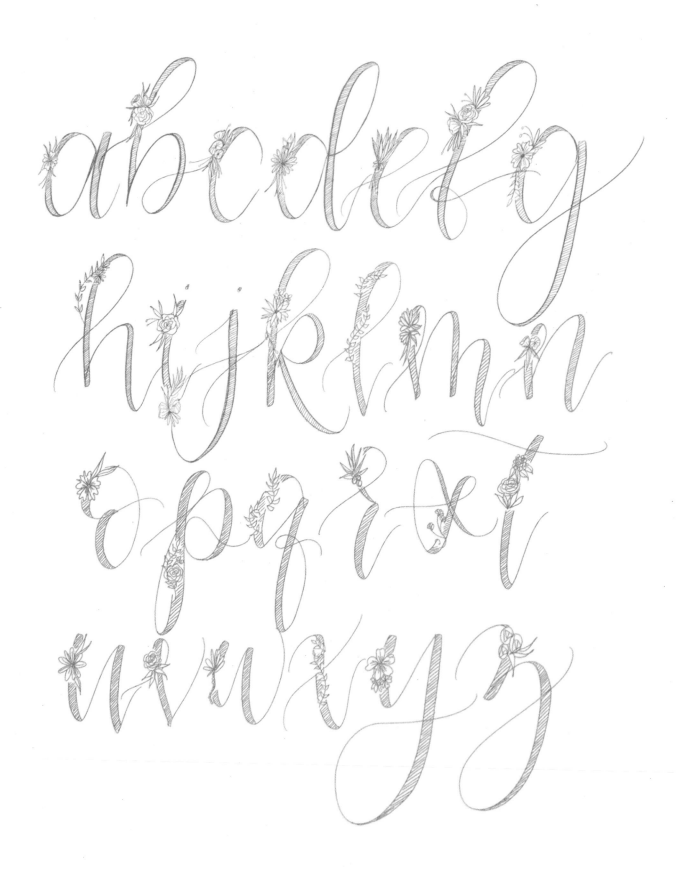

contents

Introduction: How to Use This Book 1

Tools to Get Started 13

First Steps: The Anatomy of Lettering 19

Brush Lettering 101 47

One Step Further: Introduction to
Bounce, Variety, and Flourishes 75

Put It Together:
Composition on the Page 105

Use and Share Your Skills: DIY Projects 113

Conclusion 148

Further Reading 149

Acknowledgments 150

About the Author 151

Index 152

Every
adventure
requires
a first
step

— cheshire cat

how to use this book

Welcome! I like to think of modern brush lettering as a new age twist on ornate calligraphy mixed with whimsical hand lettering. It's an artistic, structured tribute to swoon-worthy handwriting.

This book will guide you through your very own brush lettering journey, and before you know it, you'll be creating beautiful designs with a developed style that is unique to you.

In the following comprehensive lessons, you will discover tips and tricks for basic letter forms, connective spacing while creating words, and the buildup of more elaborate, flourished designs.

With focus on structure and design, you'll be prepared to take on a variety of stylistic approaches. This book breaks down the methods used to correctly apply brushstrokes. Aside from learning lettering, beginning with brush pens is a learning curve itself. You will get familiar with how to properly use a brush tip, as the varying thicknesses from applied pressure can make or break your work.

You will also learn highly desired techniques like adding bounce to your lettering, incorporating color and patterns, and integrating other mediums, along with additional effects, to your letters. You will also be taken through step-by-step instructions in a variety of projects to ignite inspiration and creativity.

practice makes progress

The beauty behind hand lettering is in the imperfections. Learning how to master flaws and channel them, creating character, is what makes your style unique to you. Breaking down these elements will give you that foundation upon which you can confidently build your craft. Oh, and one more thing—**don't be afraid to fail.**

If you cannot fail, you cannot learn

ERIC RIES

a note of inspiration: avoiding roadblocks

Inspiration pops up in basic, everyday moments. It's up to us to pay attention. It's incredibly easy to get caught up in comparison, fear, repetition, discouragement . . . the list goes on. Making the first move is easily the most difficult. There are so many things to overthink.

Possible Roadblocks

Where do I start?
Pick up the pen.

Somebody may have
already done it.
That's probably true,
but not the way you will.

I don't know how.
Learning is the fun part.

Somebody may have
already done it ~~better~~.
Differently.

That one time I tried, it was a disaster.
Practice makes progress.

Am I talented enough?
Two words: acquired skills.

I don't have time.
Fifteen minutes a day.

I can't afford it.
Check out the tools and materials
for budget friendly options.

I don't have any experience.
Even better! You have the
opportunity to learn the *right* way!

so where do you start?

Everybody starts differently. It's hard to know what route to choose when we're learning. When I embark on a learning journey, I like to dabble in all the resources I can find. We can learn from so many unique artistic perspectives.

Learn

If you're reading this book, you're already off to a great start. You will have the knowledge of important fundamentals; as a result, you will have an easier time picking up new techniques to advance you into other levels of your potential.

Be sure to source knowledge from many avenues, as you may discover an even more productive learning style. Some excellent resource channels include books, blogs, workshops, online classes, videos, social media, and more. View my resources section on page 157 for suggestions, including The Pigeon Letters' complete list (that's me!).

Network

Connect with others in the industry via online communication, local meet-ups, and social media. Just bouncing passion off of other creatives can be a huge boost in motivation and has potential to sprout amazing ideas.

Collaborate

A fun part of networking is in collaboration. This could include working together with another artist on a particular project or an idea on a grander scale. Working alongside others in the maker community is extremely beneficial. There's a small handful of handletterers compared to the population, and it's very rewarding to embrace community over competition.

community over competion.

Allow yourself to be a beginner.

NO ONE STARTS OFF BEING EXCELLENT.

Wendy Flynn

ways to use hand lettering

Here are just a few ways hand lettering can be incorporated:

Weddings

flourishes & ligatures

Font Design

stylistic choices for consistency

logoDesign

getting playful and creative

Testimonials

adding flair

Religious Art

gothic alphabet

Announcements

arches and banners

graphic Design

eye-catching transitions

Invitations

whimsical and bouncy

maps

bringing character to the journey

Certificates

sophistication

lettering vs. calligraphy vs. typography

The truth is, lettering is a subset of typography, as is calligraphy. But there are some major differences. To put it simply, hand lettering is the art of drawing letters. Note, double note, and triple note: lettering is not handwriting.

Lettering

When lettering, you do not simply begin writing and then learn techniques to apply. You are, instead, drawing. Calligraphic letters of all styles require a consistent base shape, which creates uniformity across an alphabet. Even modern calligraphy's loose, whimsical style demands attention to structure.

Lettering is not

- meant to be perfect
- a skill acquired overnight
- typography
- calligraphy

Huh? That's right. It's confusing and contradictory. Let's break it down.

Lettering should be viewed from the perspective of its overall design. It is focused on composition and is created as an art piece. It is a specific combination of letters that create a single piece. Letters are drawn, not written.

Letters are drawn, not written.

How's it done? Brush pens are primarily used to combine letters organically into a piece that is one-of-a-kind. Each letter takes on its own character, and the same letter will not display identically when drawn again. Letters are positioned to create a unique image that can be considered an illustration. This can also be done with a monoline style applied to create a variety of designs.

What's it used for? Pieces are created to showcase one design only. If a piece's letters were taken part from its puzzle and placed elsewhere, they wouldn't fit into a new puzzle. This makes lettering a custom illustrative design every single time. Lettering creates readable art that comes to life, displaying a quirky, whimsical nature.

Lettering creates readable art that comes to life, displaying a quirky, whimsical nature.

Calligraphy

Western calligraphy has origins in the Roman alphabet and was continued by monks through the dark ages. It's an age-old art form passed down to us and has changed through history—pretty cool!

What is it? Calligraphy is the art of writing letters in a single pass with a pen. It is a personalized, lovely writing form often used to compose letters, and is based on penmanship. It is an emotional form of writing, typically very meaningful to its recipients. Writing letters uses the same lettering style throughout, using muscle memory as you would with your own handwriting. Calligraphy's literal meaning is "beautiful writing."

CALLIGRAPHY'S LITERAL MEANING IS *beautiful writing.*

How's it done? Calligraphy is formed using a pointed pen with a nib that dips into ink, or with a fountain pen in which the ink flows to the nib as it's used. Its stroke is gone over only once with a single pass (whereas lettering uses multiple passes), connecting words and sentences to create ornamental memorabilia.

What's it used for? Beautiful penmanship is often found in personal letters, wedding stationery, and more.

Typography

Typography is the study of typefaces applied to letters and how letter forms interact with one another on a surface.

What is it? It's a collection of physical characters that are designed and created for reuse. Typography's similarity to hand lettering lies in displaying letter forms on a surface to create a composition. However, it is digitally based and created by typeface designers and commonly used by graphic designers. An easy way to distinguish typography is to recognize it as a font that is a collection of prefabricated letters.

How's it done? Typeface designers put a lot of work into creating fonts. They formulate letters that work together in endless combinations, which takes a high level of skill and a lot of devoted time. There are several different software programs that can be used such as Adobe Illustrator. To design, letter forms are built up bit by bit, perfecting their shape and style.

What's it used for? Typography is used everywhere, including books, websites, brochures, signs, logos, and more.

Quick Reference Comparison Chart

	HAND LETTERING	CALLIGRAPHY	TYPOGRAPHY
Characteristics	Whimsical, wispy, bubbly	Elegant, classic, ornamental, decorative	Geometric, precise, mechanical
What Stands Out	Bounce, individuality, flourishes	Handwritten, flourishes, parallel lines	Structure, consistency, font
Found Here	Wall décor, greeting cards, logos, illustrations	Letters, invitations, menus, formal events	Books, websites, branding
Used By	Artists, designers, illustrators, crafters	Poets, artists, letter writers	Graphic designers, publishers, magazines, print presses
Tools Used	Brush pens, paintbrushes, embossing materials	Nibs, dip pens, ink, fountain pens	Computer editing software

Anything's
possible if
you've got
enough nerve.

— J.K. Rowling

tools to get started

Having the right tools and materials is essential to your success in your brush lettering journey. Your pens matter. Your paper matters. There are so many options to choose from, so I've created a comprehensive guide of some of my favorite go-to supplies. Supplies can be found in local art stores and online. Amazon is a great resource if you don't have a store nearby that's loaded up on lettering supplies.

It's important to understand the differences that brush pens offer, such as their tips, flexibility, and control. Paper matters because you want to ensure you're not damaging your pen tips. Allow me to elaborate.

brush pens

Brush pens range in flexibility, which is the main thing you'll notice as you use them. For more control, you'll want tips with less flexibility because your upstrokes won't get away from you as you're learning, meaning the transition between adding and releasing pressure will be easier. The more comfortable you get, the more you'll be able to confidently use brush pens with more flexibility.

(A) Prismacolor Premier Marker
Small brush tip—4
Flexibility—9
Control—5
Small to medium lettering

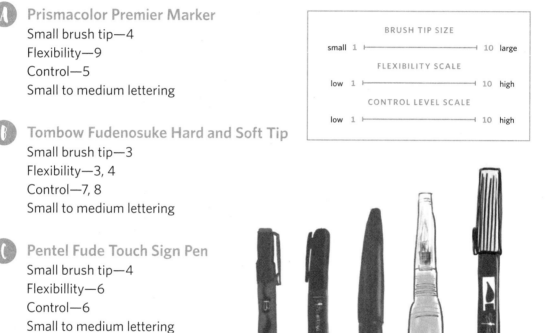

BRUSH TIP SIZE
small 1 ├────────────┤ 10 large

FLEXIBILITY SCALE
low 1 ├────────────┤ 10 high

CONTROL LEVEL SCALE
low 1 ├────────────┤ 10 high

(B) Tombow Fudenosuke Hard and Soft Tip
Small brush tip—3
Flexibility—3, 4
Control—7, 8
Small to medium lettering

(C) Pentel Fude Touch Sign Pen
Small brush tip—4
Flexibillity—6
Control—6
Small to medium lettering

(D) Pentel Aquash Water Brush
Small, medium & bold—5, 8, 10
Flexibility—10
Control—5
Medium to large lettering

(E) Tombow Dual Brush Pen
Large brush tip—9
Flexibility—5
Control—7
Large lettering

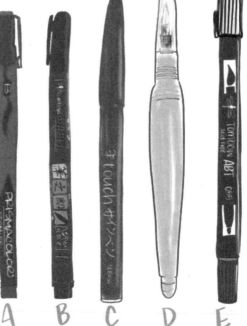

fine tip pens

These pens are great for work with consistent line thickness. It's what you'll use to practice building consistent alphabets, learning faux calligraphy, and creating hand lettered illustrations.

 Micron Pigma Ink Pens
Fade resistant
Several colors
Many size options
Doesn't bleed

 Papermate Flair
Point guard felt tip
Doesn't bleed
Twenty-six colors

Uni-Ball Gel Impact
Visible ink supply
Opaque
Writes on most materials

 Zebra Sakura Gel
Fast drying
Smudge proof
Fourteen vibrant colors
Many sizes

Gelly Roll by Sakura
Fine and medium points
Several color sets and finishes

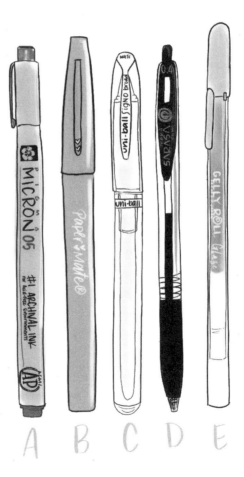

paper

What most folks don't know is that a lot of paper can ruin brush pens. Copy or printer paper, for example, contains micro fibers that will shred the tips of brush pens, causing them to fray and rendering them useless. You can grab quality paper from art stores and online. Expect to pay for quality because you get what you pay for. That said, there are some more accessible price points than others, and I'd always opt for the best value. Colored paper can even be incorporated if it's smooth enough. I'd stay away from construction paper though; for now, let's stick to the basics of getting started.

Paper for Lettering

Rhodia pads are an excellent choice for most lettering practice and projects. The paper's silky surface is the perfect partner to a brush pen's glide.

When using water brushes, I recommend using paper made specifically for watercolor. This paper is 140 lb/300g, acid free, and textured.

Benefits of Rhodia

- Reinforced stapled binding for extra strength
- Cover is scored to neatly fold back
- Stiff back cover makes writing or sketching easy and portable
- Pale violet lines and grid with 5mm intervals
- Microperforated on top for easy and clean removal
- Extra white 80g ultra smooth Clairefontaine paper
- 80 sheets of blank, lines, grids, or dots

Paper for Water Brushes

When using water brushes, it is recommended that paper made specifically for water media be used. This paper should be 140 lb/300g, acid free, and often textured. This is marketed as watercolor paper. Some watercolor paper will reflect 98 lb, which is fine, but can warp easier when water is applied. Watercolor paper can be found with a smooth or textured surface. When you see the words "cold press," the paper will be textured, while "hot press" paper will be smooth. Both are fine choices, and it ultimately comes down to personal preference. I like cold press watercolor paper because the water won't spread away from you as easily as it does with a smooth surface.

tip

On a tight budget? Just grab a Tombow Fudenosuke 2-pack and hard and soft tip brush pens or a Rhodia dot or blank pad. Purchasing your first lettering kit doesn't have to break the bank.

first steps: the anatomy of lettering

There are a lot of terms for lettering that you'll see come up when you first dive into lettering. Although many of these words and terms have evolved from traditional font sets, you'll find that learning these terms will give you a better understanding when they do pop up. There's nothing like trying to pick up new information externally and not knowing what it means! Let's break it down and make it a little easier with some visual examples.

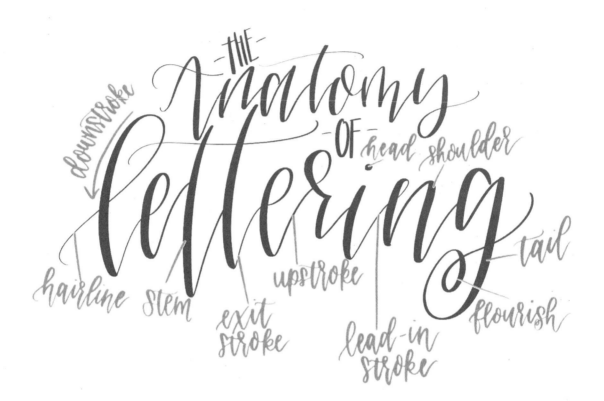

The Anatomy of Lettering

downstroke · head · shoulder · hairline · stem · upstroke · tail · exit stroke · lead-in stroke · flourish

Swash
Exaggerated serif.

B B B

Ligatures
Lines that creatively connect letters
or words together.

the adventure

Crossbar
Horizontal stroke.

A H

Mood
The look and feel of letters and fonts.

whimsical
sweet
romantic
bubbly

Flourish
A decorative, ornamental stroke
(swashes are in this category).

Bounce
When downstrokes dip below the baseline
to create character.

dream
REGULAR

dream
BOUNCE

guidelines

What are all those lines?

Guidelines will help you form your letters with precision. In the beginning, it's crucial to pay attention to these lines because it will help you develop a cohesive alphabet. The more you practice with guidelines, the more muscle memory you will build. You can even create quick guidelines on your own with a ruler and add more lines or include fewer, depending on what practice you're focusing on at the moment.

Ascender: Part of lowercase letters that may rise above the cap height.

Cap Height: The height of a capital letter.

Mean Line: The height of a lowercase letter.

X-Height: The distance between the baseline and the mean line of lowercase letters.

Baseline: The line on which the text "sits."

Descender: The portion of letters that dip below the baseline.

ASCENDER
CAP HEIGHT
X-HEIGHT
BASELINE
DESCENDER

Whimsy

You'll find that traditional calligraphy has a hard focus on the structure and shape of letters, while modern lettering has a strong emphasis on all the unique ways to stretch traditional rules. You'll free up these rules by softening letter structures while maintaining the basic shapes, and you can use guidelines as a base while you'll also break the rules and let your strokes reach above and below these lines from time to time.

Whimsy

Modern lettering allows for a softer, rounder, looser letter form. It can be intentionally irregular, which largely contributes to its charm. I call this imperfectly perfect.

Whimsy

practice sheets

Before we dive into the explorative journey of lettering, I strongly encourage you to make photocopies of the practice sheets from the following pages. Although there are spaces for practice throughout this book, it will be helpful to have extras on hand!

The dotted practice sheet will help you keep straight lines while maintaining each letterform. The dashed middle line practice sheet is a basic guide for keeping straight lines. The sheet that has multiple horizontal lines assists with learning to utilize all points of a letter including the baseline, x-height, cap height, and ascenders and descenders. You can use both varieties of slanted line practice sheets to keep your lines straight while creating uniformed slanted letters.

letter formation

I'm going to introduce a method that I use to explain letter formation. You want a cohesive alphabet, and letter shapes themselves need guides just as much as words and sentences need guidelines. We'll use what I call the four corner (or three corner) method. These corners are touch points. I prefer using only three main corners to form my letters. Think of it like a magnet. Instead of circling back around, once your letter reaches its third touch point, it shoots right back up to the beginning. It's okay if your letters look choppy and sharp as you practice this. The idea is to create the muscle memory.

As we dive in, use a regular fine point pen. As much as you might be tempted to use a brush pen, we're not there yet! This is an important step of the process of learning, even if you've already dabbled in brush lettering.

Create Base Shapes

Use four corners as a guide

Utilizes all touch points

e.g. shape #1

e.g. shape #2

abcd abcd

Utilizes only three

Keep Parallel Lines

a/m AXIS

Keep Consistent Height and Space

do this ➛ b d g h j k l q

WIDE NARROW NARROW SHORT, WIDE WIDE
 NARROW

not this ➛ b d g h j k l q NARROW

WIDE,
LONG

tip

It's fine if you prefer more or less
height/spade as long as all your
letters remain uniform. (The G,
K, and L would be a great style
grouping.)

practice utilizing touch points

Use a ballpoint pen to form your letter shapes below.

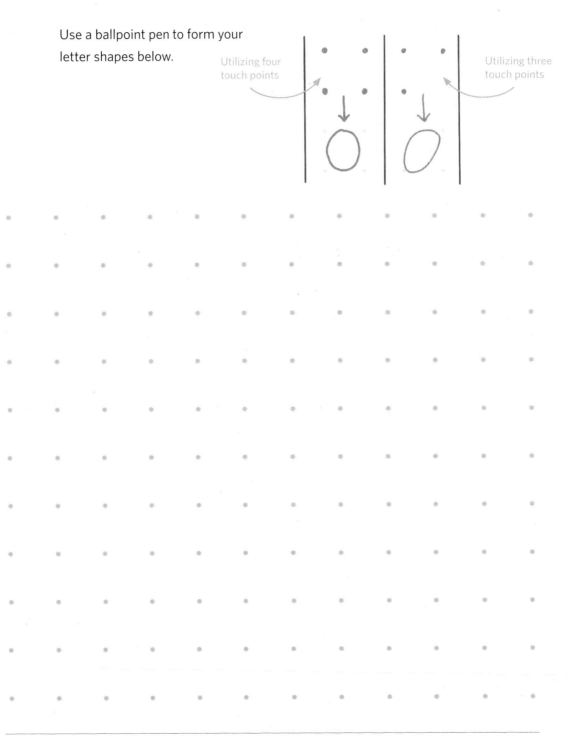

Utilizing four touch points

Utilizing three touch points

letter forms a–j

Learn how to build letters before building words. Try lifting your pen after your first stroke for more control. Remember, you're still using a regular, fine-tip pen.

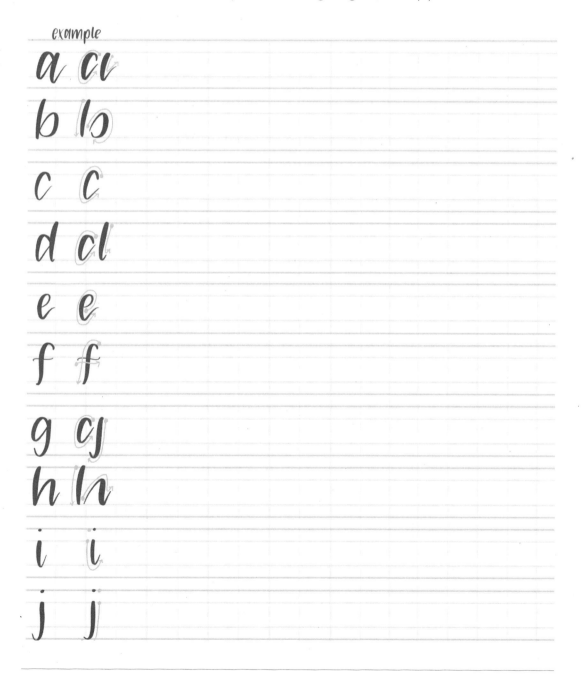

example

a a

b b

c c

d d

e e

f f

g g

h h

i i

j j

letter forms k–t

Notice the base shape of each letter as you practice building it. Are the shapes uniform?

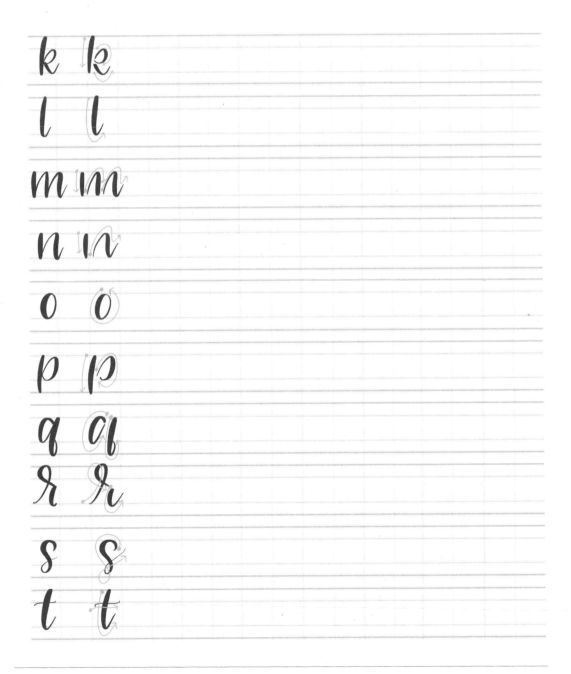

letter forms u–z

Practicing a steady pattern will give you the tools to branch out into your own style.

u u

v v

w w

x x

y y

z z

KEEP GOING!
CONTINUE THE LETTERS THAT YOU
FIND MORE CHALLENGING.

let's connect!

There are several factors to consider when determining how you will connect your letters. Understanding the relationships between letters will allow you to break the rules and get creative.

The Length of Lead-in and Exit Strokes

When I first started my lettering journey, I wanted to produce beautiful, airy letters with long, wispy exit strokes. My natural progression didn't end up that way, so my go-to style is a bit different. That said, once you get familiar with placing intentional length in your exit strokes, you'll be able to switch between styles!

dandelion

dandelion
NARROW

dandelion
LONG

The Direction of Lead-in and Exit Strokes

Notice how a soft curve upward makes your word look a little more bubbly and cute, while the hard curve up and over looks a little more airy. This is also a creative choice in your exit strokes that will evoke different moods in your work.

labrador
SOFT CURVE UPWARD

labrador
HARD CURVE UP AND "OVER"

rules for making words

Connections can be tricky when too much thought is put into them. Remember the following rules and you'll find this process to be much easier.

Rule #1

Stop your exit stroke before beginning the next letter. Lift your pen off the paper for each break. Basically, treat each letter as a stand-alone letter. This will come in handy when you begin incorporating flourishes!

rainbow

In the word above, for example, here are all the places I stopped, lifted my pen, and then continued the next letter.

rainbow

Rule #2

Don't worry about your connecting lines matching up perfectly. Notice where my "n" connects to my "b" in both examples. I didn't worry about where the lead-in for my "b" would connect. Rather, I treated it as its own beginning. Below is the same rule with a flourish incorporated.

rainbow

Rule #3

Be sure that your connecting strokes are consistent in length. Even with a solid base shape, if spacing is inconsistent, the word can turn out a bit sloppy. It doesn't matter if the connecting strokes are long or short, but consistency is key.

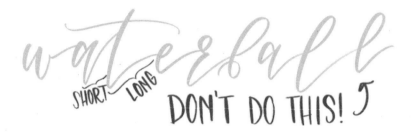

waterfall
SHORT LONG DON'T DO THIS!

(DO THIS INSTEAD)

waterfall
CONSISTENT SHORTER SPACING

(OR THIS)

waterfall
CONSISTENT LONGER SPACING

practice creating words

Find your style by writing the same word with short spacing and then long spacing to see which resonates with you more! You're still only using a regular fine-tip pen—don't forget!

Now that we've come this far, how about a proper introduction? Write your name using your new letter formations.

How about some more about you?

OCCUPATION:

HOBBIES:

faux calligraphy

Once you feel comfortable with your letters, you can begin to add weight to them. Not only will this help you learn where your weight lines will go, but it will also prepare you for odd projects that can't be done on a small piece of paper. For example, if you want to do lettering on a window with a paint pen, this technique will come in handy. We're not quite ready for the brush pen though, so don't jump in just yet! We will begin adding weight using a nifty technique known as faux calligraphy. It's easy! Here's how you do it.

When you write a letter, pay attention to your upstrokes and downstrokes. Strokes 1 and 3 are downstrokes, amd strokes 2 and 4 are upstrokes. Draw a line very close to the downstrokes of your letters, connecting the lines at the beginning and end of the weight line. Keep your lines consistent and choose whether you want your connections rounded or more square.

abcdefg
hijklm
nopqrs
tuvwxyz

After familiarizing yourself with weight line placement, all you need to do is fill in the white space. You can do this by coloring in the empty space, which imitates the appearance of a brush pen.

Step One: Use consistent base shapes to letter a word
Step Two: Add weight line to downstrokes
Step Three: Color in white space

strawberry

Practice Adding Weight

Follow the prompts below to practice adding weight. Have fun!

favorite color

favorite flower

hometown

best friend

favorite animal

role model

tip

Keep the same distance between each letter and its weight line.

Faux Calligraphy Practice

I encourage you to use your creativity and draw a pattern inside the empty spaces you've created between the letter line and the weight line in your letters. Fill this space with a color other than black. Try using pink, blue, or polka dots!

tip

Try using alternating colors in the letters or words.

Pattern Play

How many can you come up with?

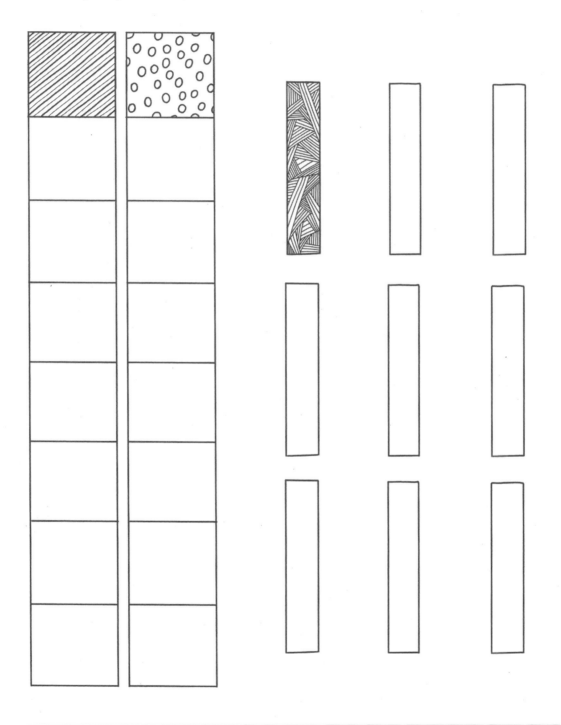

I'm still learning.

— michelangelo, age 87

brush lettering 101

We've gone over how to form your letters, how to experiment with different creative choices, how to build words, to alter the style and mood of your words, and where to apply weight lines—and it's finally time to pick up the brush pen that's probably been staring at you begging to be used!

As you start this chapter, it's important to remember that practice makes progress. The more you use your brush pen, the more comfortable it will feel. You'll probably surprise yourself with your progress as you practice, so keep at it! We'll start simply, and learn how to properly use brush pens with their basic strokes, which will help you easily transition into letters and words.

beginning practices to learn how to use a brush pen

YOU'VE GOTTEN PRETTY COMFORTABLE WITH YOUR BASE SHAPES? SWELL!

FEEL GOOD ABOUT WHERE TO ADD WEIGHT TO YOUR LETTERS? SUPER!

Keeping all previous lessons in mind, add this rule: press firmly on your downstrokes. This causes the brush to flatten and create a thicker downstroke line. This adds weight to your letters. Release pressure on your upstrokes. This will make the brush return to its pointed tip.

ARE YOU READY FOR THE brush pen? let's go!

basic strokes

Holding your pen at a 35- to 45-degree angle will help you achieve the ideal weight lines by giving you more control. I'm an overwriter when it comes to regular writing, which means I grip my pens like my life depends on it and the tip reaches toward me instead of away from me. Chances are you won't hold your brush pens like you do with regular pens. Remember, you're drawing, not writing. You want your brush pen to sit looser in your hand so that it can flow with ease.

When practicing, you'll find that you go through a ton of paper. I encourage you to use tracing paper over a guide, which will help a lot with your end result. Don't underestimate the power of using guidelines!

Take a closer look at downstrokes and upstrokes.

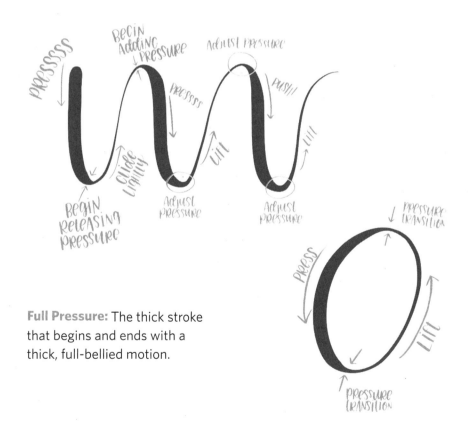

Full Pressure: The thick stroke that begins and ends with a thick, full-bellied motion.

Entry Stroke: The hairline stroke leading into the beginning of a letter.

Underturn: The scooping U-shaped stroke that begins with a thick downstroke and curves upward in a scooping motion into a thin, hairline upstroke.

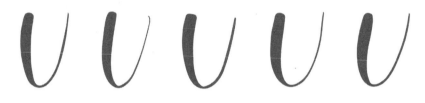

Overturn: The arched upside-down U-shaped stroke that begins with a thin upstroke and curves over into a thick downstroke.

Compound Curve: Combines the underturn and overturn strokes to create a seamless, wavy stroke.

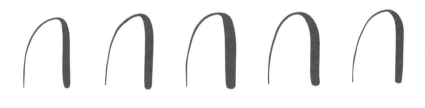

Oval: Combines the underturn and overturn stroke, creating an enclosed rounded shape.

Ascending Stem Loop: The stroke beginning in an upward, hairline curve, transitioning into a thick stroke downward.

Descending Stem Loop: The thick stroke moving downward and then curving upward into a thin line that meets the middle of the downstroke.

It's crucial that you familiarize yourself with these basic strokes and continue to return to these practices along your lettering journey. Each brush pen is unique in its flexibility and size, so these basics will come in handy while breaking in those new tools. When it comes to the amount of time you dedicate to practice, fifteen minutes a day is awesome. If you don't have that much time, even five minutes does wonders because you're putting energy into the work. Don't stray away from applying your creativity because you feel like you don't have time to sit down and create a big project. Just sit down and create some basic strokes!

Now go use the following pages to complete two lines of each of these shapes and watch your strokes improve!

practice basic strokes

DOWNSTROKES | | | | | | / / / / / / /
UPSTROKES | | | | | | / / / / / / /

UNDERTURN U U U U U U
OVERTURN ∩ ∩ ∩ ∩ ∩ ∩

ENTRY STROKE /////
FULL PRESSURE |||||||

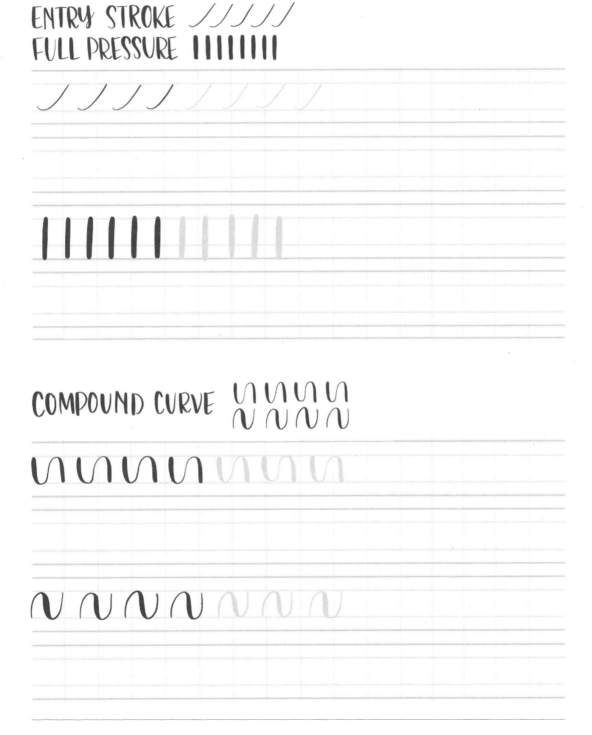

COMPOUND CURVE

OVAL *O O O O O O*

O O O O O O O

ASCENDER LOOP STEM *P P P P P P*
DESCENDER LOOP STEM *J J J J J J*

P P P P P P P P

J J J J J J J J

strokes in letters

Now we'll use these brushstrokes in our letters. You will find some of these brushstrokes in the following letters. After you take a look at the letters below, try to re-create them using your basic strokes on the next page.

∩ OVERTURN *a b c d e g h m n p q*

∪ UNDERTURN *e g q s u w y*

O OVAL *a b d g k o p q*

⋃ COMPOUND CURVE *M*

ʃ ASCENDER STEM LOOP *b d f h k l*

ʃ DESCENDER STEM LOOP *f g j q y z*

try it out!

UNDERSTROKE

DESCENDER STEM LOOP

OVAL

UNDERSTROKE

left handed?

You can just as successfully learn to master lettering as your right-handed neighbor. The struggle is real. The biggest road block for both "lefties" and "righties" always comes down to mental barriers. You will be the only one holding you back. If this block stemmed from the feeling of failure, perhaps due to a messy attempt complete with an ink-stained hand and smudged up paper, hold onto this thought: Mental barriers can exist even when you haven't tried yet because of fear of failure. Well, guess what? Everybody starts somewhere!

Here are a couple of tips for left-handed aspiring letterers.

Try adjusting the angle of the pen.

Left-handed writers are both underwriters (keeping the wrist straight and holding the pen above) and overwriters (curling the wrist and holding the pen underneath). If you're an overwriter, you may be familiar with smudging your work as your hand follows. If using a different angle with the pen doesn't work in your favor, try keeping a regular pen angle and instead just adjust the angle of the paper.

Some lefties use hand guards.

They create a barrier in between your letters and your hand. You can find them online. I can't vouch for them because I've never used them, but they may work great for you! There are also a lot of tutorials online by left-handed letterers that want to help!

alphabet sampler

Do you ever see a piece of artwork that makes you feel a particular way? Perhaps a chalkboard advertisement for fresh navel oranges that gives you a sense of its citrus texture? Or a stunning, delicate wedding invitation invoking the fragile feeling of precious love? How about an eye-catching sleek, modern business card that gives you confidence that the company or individual is "the real deal"?

These mood-invoking designs are largely due to the stylistic choices of the lettering.

EXAMPLES:

whimsy Bubbly PLAYFUL Airy

The following pages present ten different ways to create each uppercase letter, ten ways for each lowercase letter, and ten ways to create numbers.

what are you trying to say?

alphabet styles

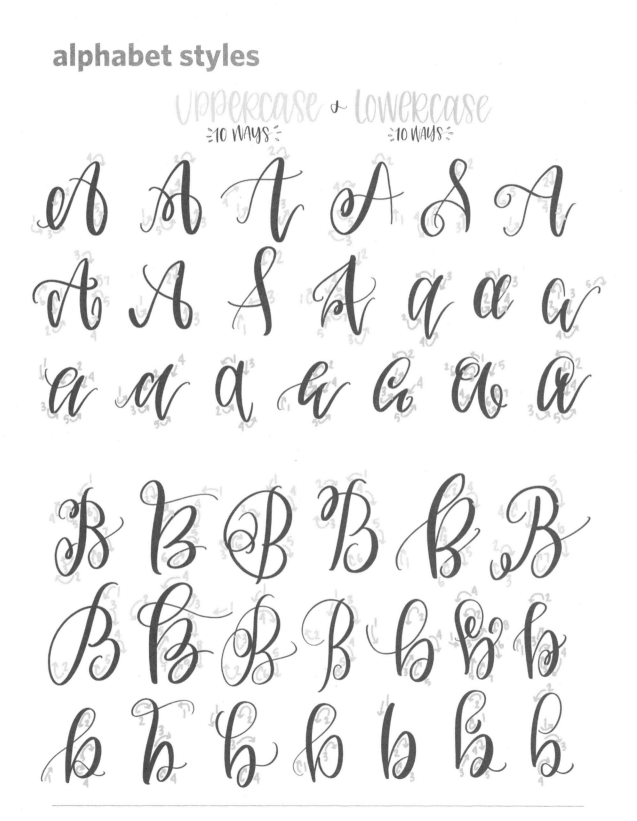

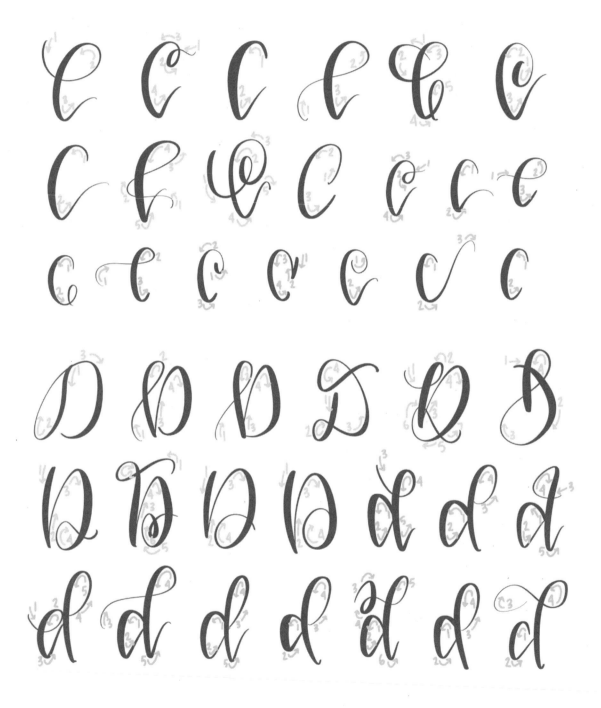

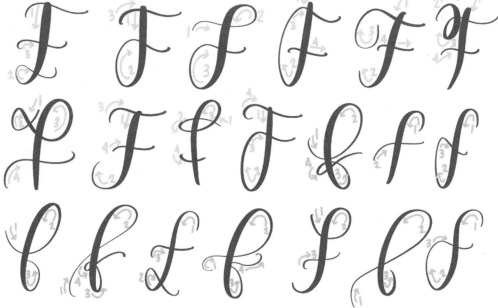

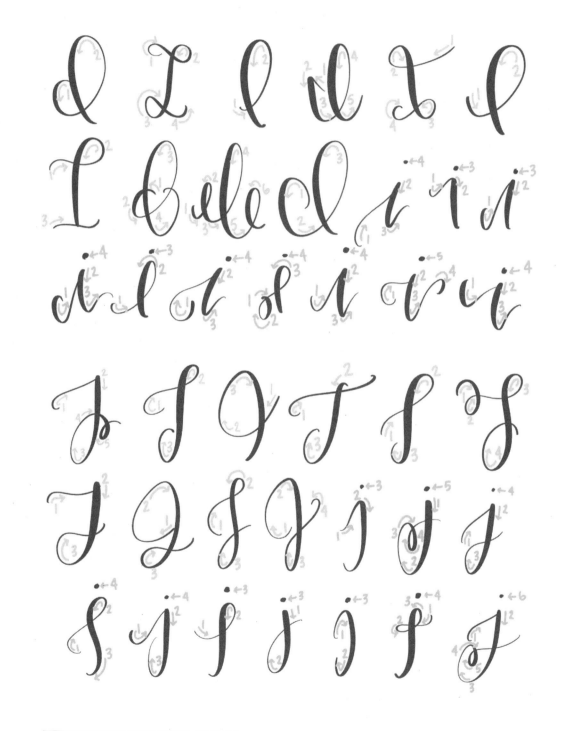

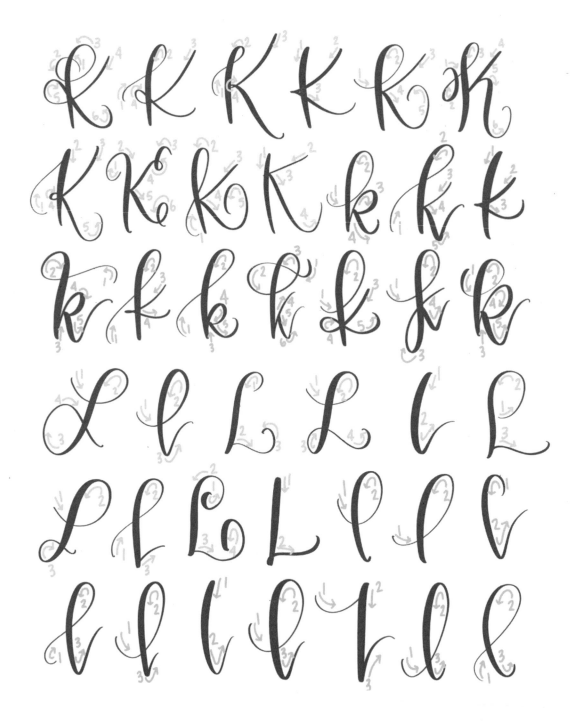

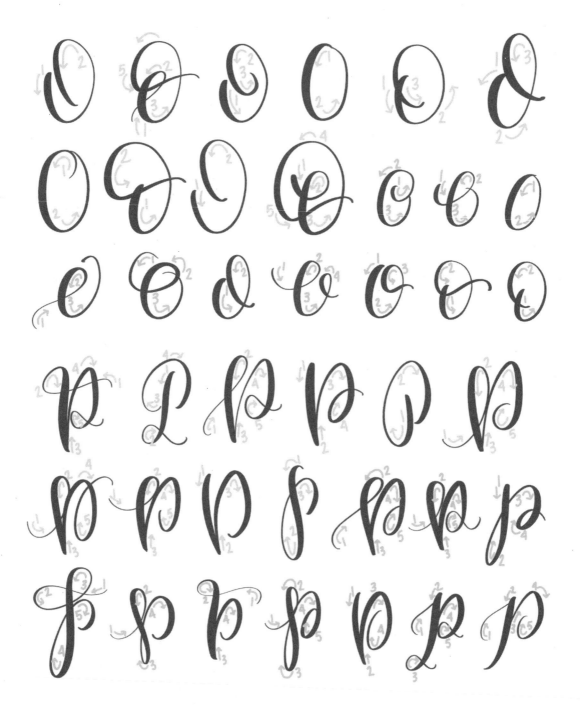

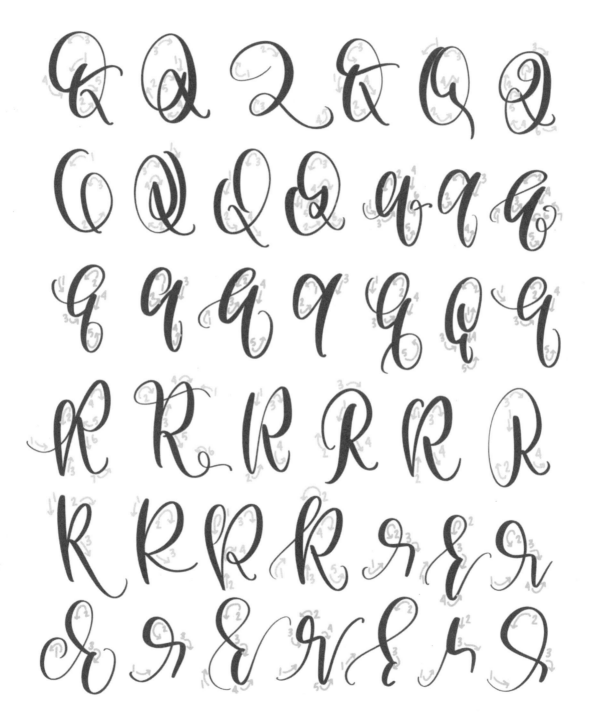

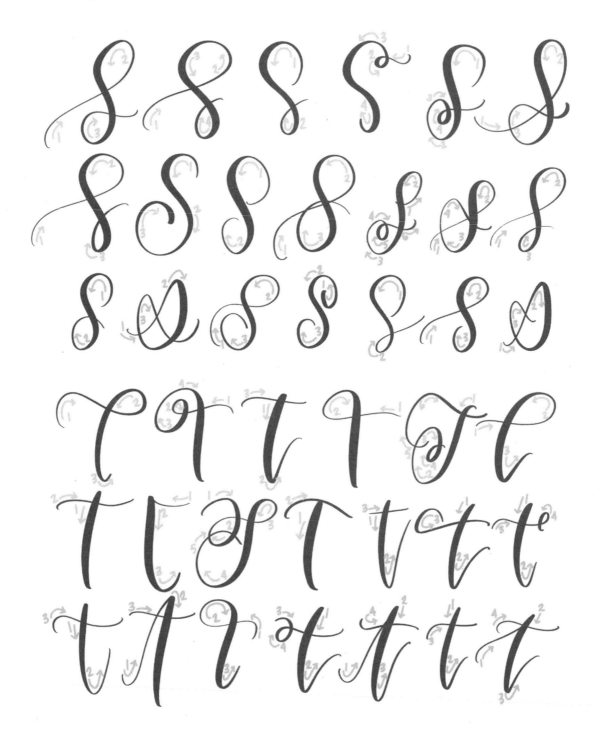

numeric style

How many different styles can you think of for each number?

Practice Numbers

Intro to bounce

one step further: introduction to bounce, variety, and flourishes

Bounce lettering is all the rave! It's what really makes modern calligraphy stand out. Bouncing your letters typically occurs in ascending and descending lines, as you can play with them to reach much higher and drop much lower than their typical guidelines. You'll also find that you can break up repetition by staggering repeating letters. Bounce lettering adds energy and personality to your letters. Once you feel comfortable with your basic forms, I encourage you to dive into experimenting with this process, and don't be discouraged if it doesn't come out exactly like you thought it would. Practice makes progress!

bounce

When the exit stroke of a letter is naturally directed downward, you can dip below the descender line. Be sure to return to the base line every few letters to maintain balance in your words.

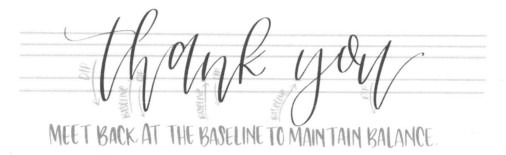

When the exit stroke naturally drags upward, you can reach above the ascender line.

Practice Your Bounce!

Choose an animal and letter its name a few different ways using bounce lettering.

tip

Return your pen to the baseline every few letters.

practice creating swashes

Swashes bring a little more life to the beginning and ending letters in a word or a sentence. Instead of a basic, boring beginning, swashes add a bit of flair!

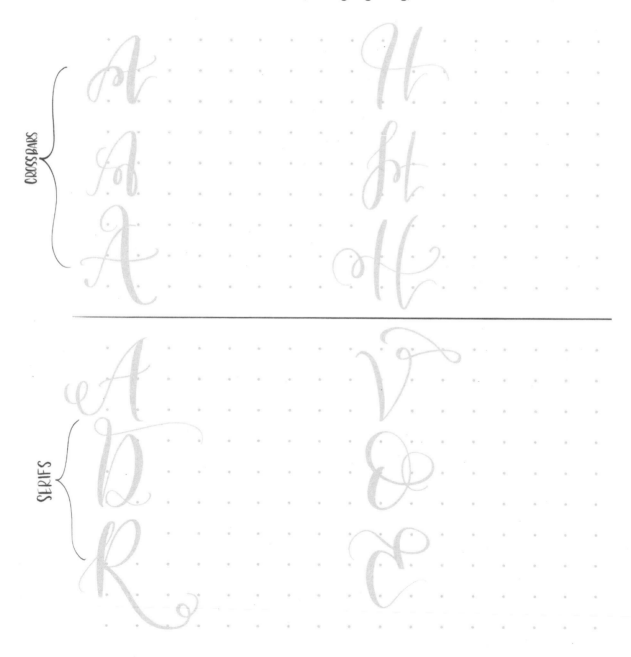

CROSS BARS

SERIFS

Create Your Own!

tip

Avoid crossing thick lines with other thick lines.

practice creating ascenders and descenders

Practice incorporating swashes with ascenders and descenders by lettering the names of your friends and family.

Let's Play Make Believe

Did you ever use made-up words as a kid? Do you recall any crazy combinations of letters or sounds? Well, you get to revisit that time and create new made-up word.

Use this box to jot down your word ideas.

Once you've chosen your favorite creation, display it proudly! Write it here.

You've got your word, but it needs a definition!

style exploration

Do you find that you feel differently reading this word versus this word?

sweet *Sweet*

Depending on the style applied to a word's structure, it will naturally translate to different moods, creating a unique feel to each variation. Let's give your word some new vibes! Use the prompts to letter your freshly created word.

shallow
X-HEIGHT

deep
X-HEIGHT

bounce

slanted

bubbly

long

flourishes

The options go on and on!

faux

wide

skinny

eyes closed

slow

fast

NON-dominant HAND

How much fun is style exploration?! It's a great activity to return to when prepping a design. Let's keep going. See how many different ways you can letter your name!

practice more variety

Creativity has the ability to blossom with hand lettering. Incorporate some variety and experiment with different letter styles!

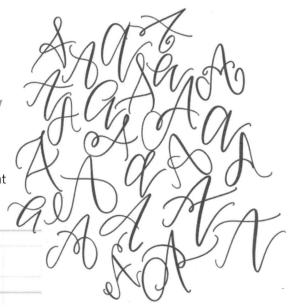

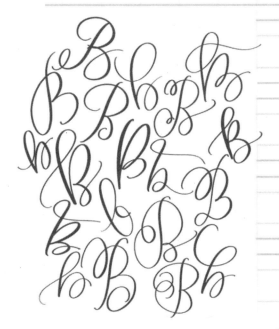

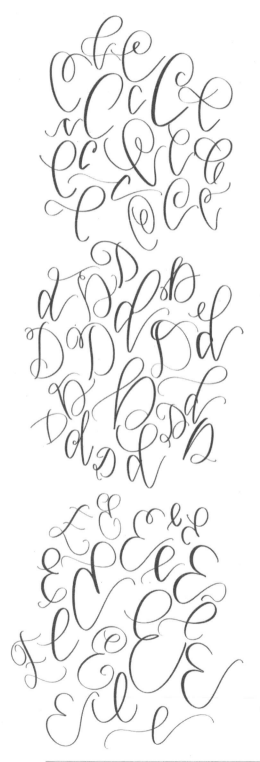

There's a lot you can do with simpler letters such as "c" and "o," which wouldn't seem like they'd have much variety.

Try ten different swashes. Circle your favorite.

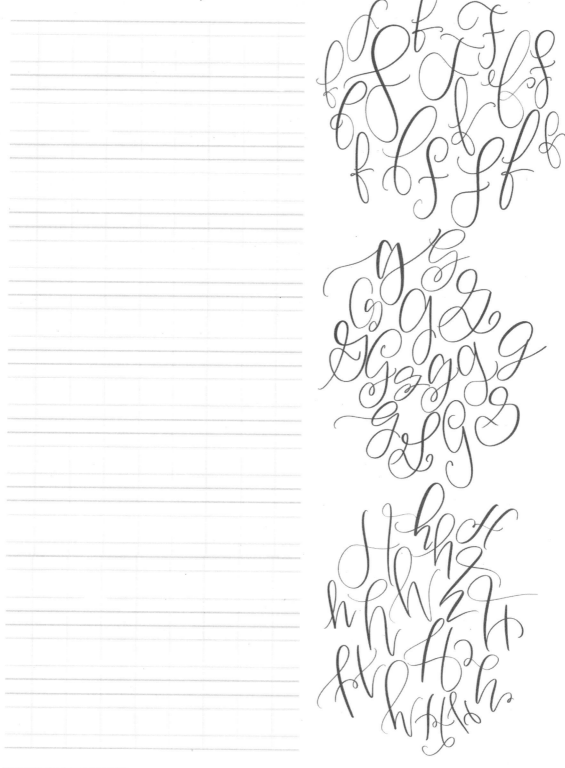

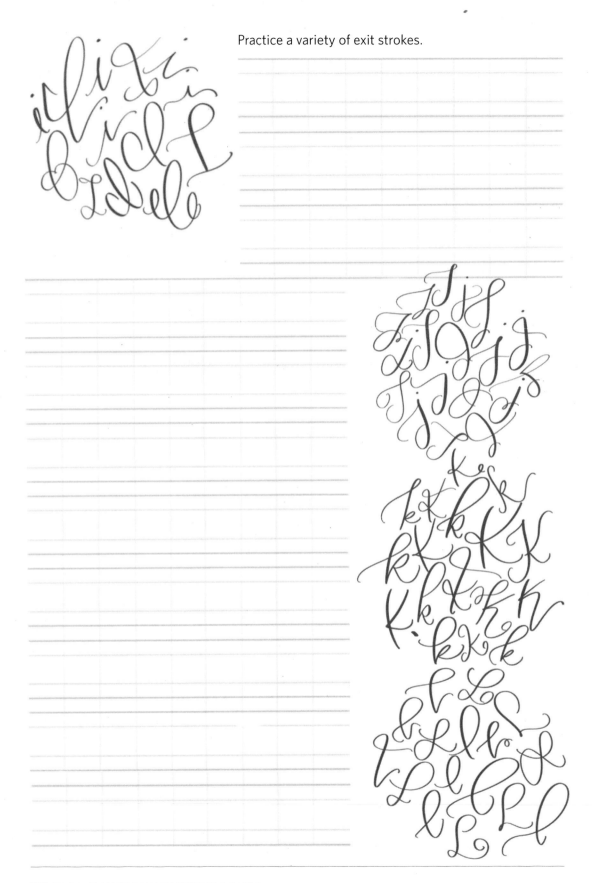

Practice a variety of exit strokes.

Try dropping beneath the descender a few times.

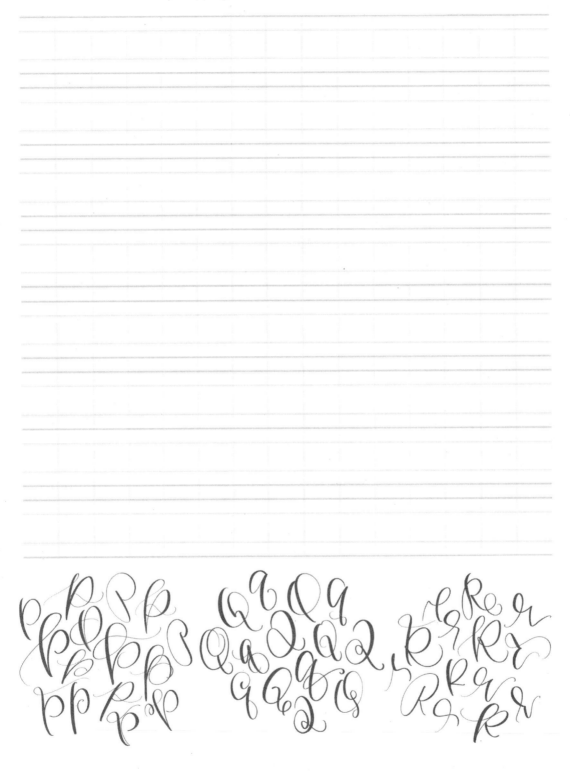

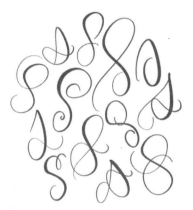

Try drawing a different style for each letter. You can do it!

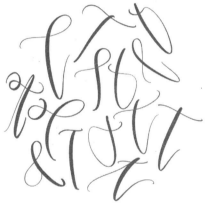

Practice varying degrees of understrokes.

Try some wispy hairline strokes.

flourishes

A flourish is an ornamental flowing curve used to embellish lettering designs.

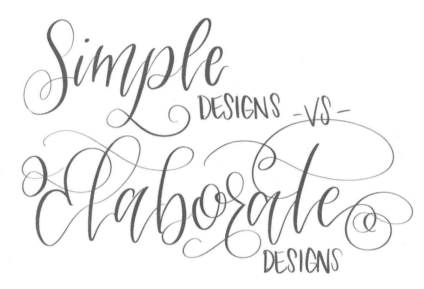

Simple flourishes are a lovely addition to words and designs that don't necessarily need to stand out, but that could benefit from a softer polished appearance. Elaborate flourishes transform a basic design by adding a high degree of elegance. The addition of fancy flourishes alone can complete a logo, a greeting card, an announcement, a menu, and more.

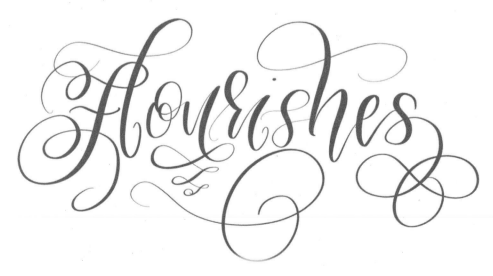

Where to add flourishes:

- at the beginning/end of a word
- at the top of an ascending stem
- at the bottom of a descending tail

You can also add them on stems and tails of words.

beginning

ending

Stems: *b a h k* ETC.

Tails: *g j l* ETC.

Look at the differences of a basic word after adding simple flourishes and elaborate flourishes.

basic bounce lettering apple

apple *simple flourishes*

elaborate flourishes apple

Adding Ligatures

Flourishes can also be used for ligatures, which are lines used to join two letters together, sometimes in clever, unexpected ways, as in the examples below.

in common words

in names

limitless

in longer words

adventure

lettering

**in occurrences of
double letters**

scribble

Standalone Flourishes

Let's not forget about all the design possibilities awaiting when we incorporate flourishes that are not attached to letters. These add-ons are used with existing flourished words, often as page dividers, underlines, and decorations. There are many styles of standalone flourishes to consider when setting the mood of your piece. Here are some examples to get you started.

SINGLE LINE

DOUBLE LINE

STANDALONE FLOURISHES

LOOPS CURLS

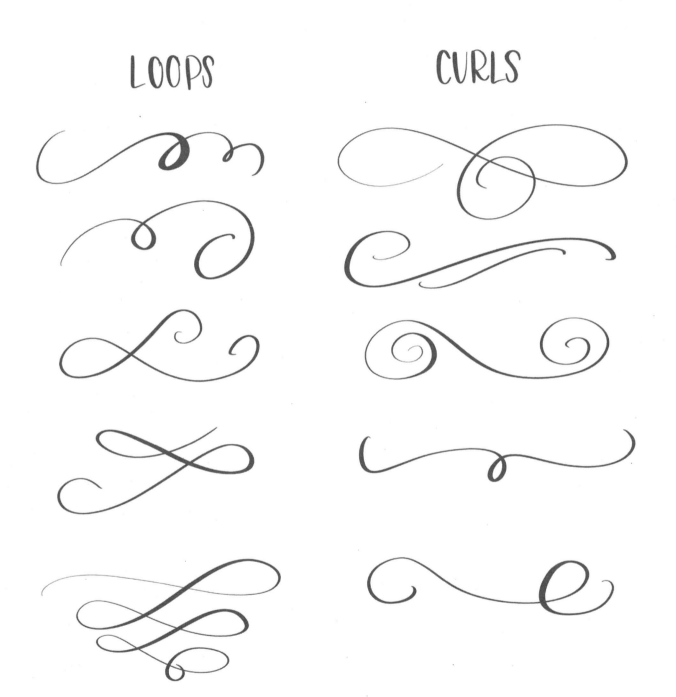

BUILDABLE

Practice Decorative Flourishes

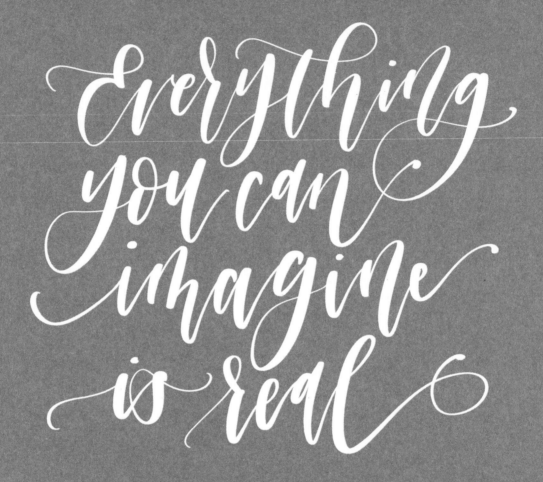

Everything you can imagine is real

– Pablo Picasso

put it together: composition on the page

How you decide to arrange and draw your words is the work of composition. You're building an illustration to make sense on paper as a piece of art. Small sketches are a great way to determine how you want to place your words. This is also very useful in placing flourishes. Although lettering is lovely on its own, building a piece of art takes thought, and composition should be part of that thought.

Using a pencil before using a brush pen can save you a lot of time and paper, as mistakes can be fixed. These examples feature several tips on how to best execute layouts.

three words, same size

Place the middle word first. This ensures the piece is centered. Use the middle word as a guide for where your words above and below can reach and dip into the middle word's frame. When you're happy with your composition, apply ink with your brush pen. If needed, erase any remaining pencil lines (but be sure the ink is completely dry first).

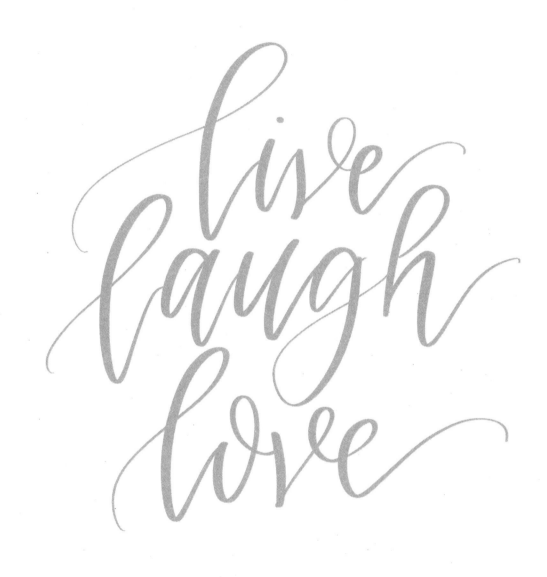

multiple words with attention to one

Just as you placed your middle word as your guide, you will place your emphasized word first, making it larger than the other words will be.

Lettering the remaining words in the same style is lovely, and you can work inside the main word's frame as you did before.

That being said, mixing other lettering styles can be complementary and add a more dynamic aesthetic.

multiple words with focus on several

First, lay out your main words that you want emphasized.

Second, add secondary words while using the main words as guides.

Lastly, add the remaining words to complete your composition.

tip

It doesn't take much to lay out some possibilities before beginning your piece, so I encourage you to practice a few sketches ahead of time so that you're confident in your layout!

If your
dreams
don't
SCARE
you,
they're not
big
enough

— Ellen Johnson Sirleaf

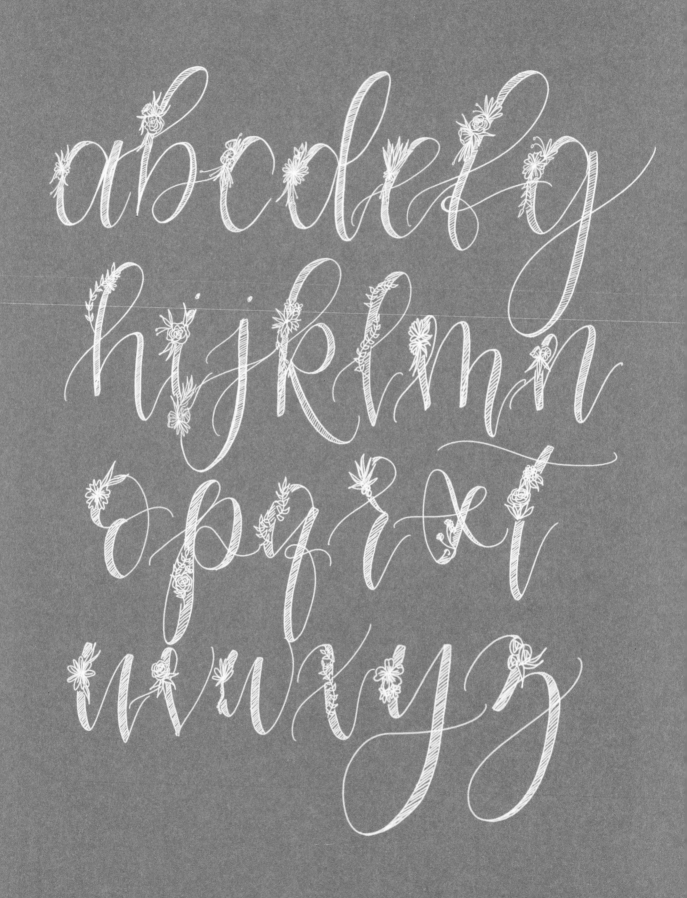

use and share your skills: DIY projects

Now that you've equipped yourself with new knowledge and mad lettering skills, it's time to put it all to use in some projects! Use the following pages to prompt the DIYer in you to start creating. You can incorporate lettering into so many fun projects! It's one of the creative hobbies that I've picked up and never put down. If you want inspiration, you probably know that Pinterest is a jackpot of ideas to try. Just don't do that thing where you feel the urge to create so you jump on Pinterest for an idea, but instead of diving into something fun, you start pinning instead. Before you know it, three hours will have passed and you'll have run out of time to do the actual creating! We're all guilty. I upload content to my Instagram daily, so come on over and follow my feed, @thepigeonletters, to jump-start your motivation! You've got the creativity ready to burst out of you, so follow that drive!

create a bunting

I don't know about you, but I'm obsessed with these. They're adorable and anything on a string screams "Hang me up!" Add some lettering to a bunting and you're set for any upcoming events.

MATERIALS

- White cardstock
- Colored cardstock
- Scissors
- Brush pen
- Adhesive
- Hole punch
- Twine

Step 1

Select about two pieces of white card or lightly colored cardstock. You may need more depending on the length of your word or phrase. Cut your cardstock into long, triangular sections in the same quantity as the number of letters that are in your word or phrase. Be sure to cut your triangles wide enough to fit your letters. Cut a straight line after the triangles to create the next batch.

tip

Cutting a straight line after the triangles creates another batch.

Step 2

Use your brush pen to write the letters you're using onto the white cardstock. Create guidelines using pencil if you'd like to keep them extra straight.

tip

Leave even more room on the top to allow for string.

Step 3

Select the same amount of colored cardstock as used from the white paper. Use the white pieces as a guide, and leaving a small border, cut triangles just a bit larger than the size of the first cuts. The background color will make the letters really pop!

Step 4

Adhere the two pieces of cardstock. Then, use a hole punch to punch two holes to create the space that the twine will be threaded through. Cut a length of twine long enough for all the cardstock flags to fit and so that there is slack at the ends.

Step 5

String the twine through, starting behind, then through again from the front toward the back, and voila! You can now grab a couple of thumbtacks and hang your darling bunting!

AND ⇒VOILA!⇐

watercolor place cards

MATERIALS

- Scissors
- Brush pen
- Thick watercolor or mixed media paper
- Watercolor paints
- A small paintbrush

Everybody loves a watercolor wash. Adding beautifully lettered names to that? People will keep them forever!

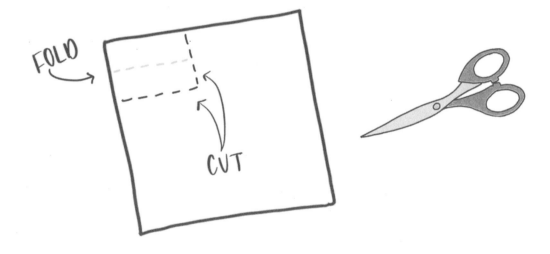

Step 1

Determine what size you'd like the face of your place cards to be. Double that size (this will allow for the fold so that they stand up), and cut out the number of place cards you'll be using. You can also use a paper cutter.

Step 2

Crease the middle to create a fold, and then open and lay flat. You'll now be able to visually separate the front from the back, with the front below the crease.

Step 3

Lay a watercolor wash over the front area. This is where stylistic choices come into play. You can lay watercolor edge to edge or apply the wash to only a concentrated area. Add an additional color or two for more vibrancy and dimension.

edge to edge

concentrated

tip

Lay a water-only wash first, and then add color to create a lovely bleed effect.

Step 4

After the watercolor dries, hand letter the names for your place cards directly on top of the dried paint.

Step 5

Refold, and you're ready to set up your place cards on a table!

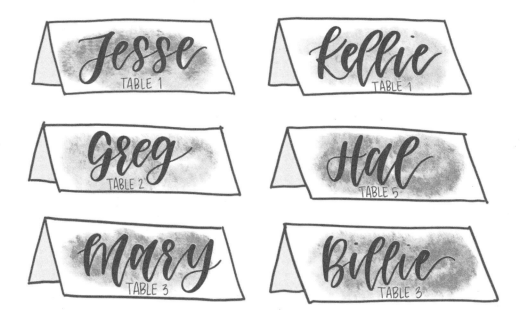

silhouette word collage

Word silhouettes make the best gifts. Receiving a personalized gift is already thoughtful—and so unique when it has special words associated with the shape. Using the profile of a loved one and putting words in that describe them will surely bring tears of joy.

MATERIALS

- Pencil
- Paper
- Brush pen

Step 1

Find an image with a clear outline.

Step 2

Draw or trace only the outline of your image with pencil.

Step 3

Fill the shape with any words you like. Some ideas of what to include are: physical characteristics, purpose it serves, roles you might see it in, aliases/synonyms/nicknames, quotes/song lyrics, where it's commonly found, how it makes you feel, and associated words. Hug the outline with words to preserve its shape. Once the ink is dry, erase the pencil outline.

Step 4

Use a frame to silhouette your subject.

embossing

Embossing is a fun finish to any project. You can add texture, shine, and sparkle to both simple and elaborate designs. There are a number of embossing tools to explore, and I encourage playing around with what intrigues you. Embossing pens have really opened the door for opportunity in design. Embossing pens can be found with brush tips, hard felt tips, and even glue roller tips. Different effects can be made with different powder finishes. Project moods can be better interpreted by the color palette. Unlikely materials can be transformed by the unexpected embossed embellishments.

MATERIALS

- Embossing powder
- Embossing pens
- A heat tool
- Cardstock

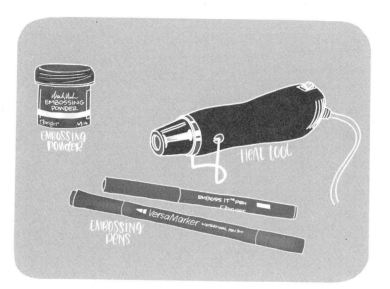

Step 1

First use a pencil to create your layout to eliminate unbalanced composition, and then draw the word(s) or design you will be embossing onto your paper with the embossing pen.

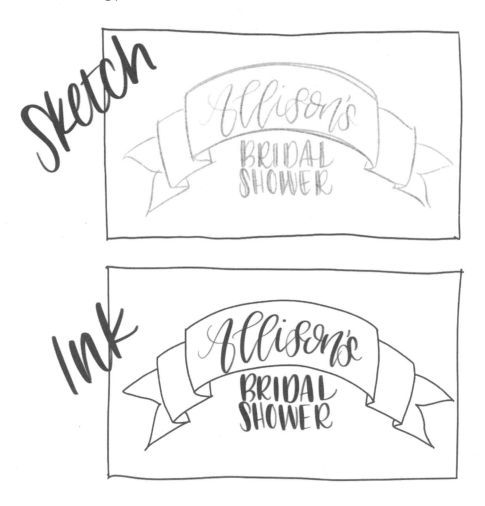

tip

Don't ink the entire design if it's large or more intricate—you don't want to risk it drying out before you're finished.

Step 2

Lay embossing powder over the entire design, ensuring no areas are left exposed.

After the design has been covered, lift the paper and pour the powder off. The powder will remain only on the areas where the embossing pen was used.

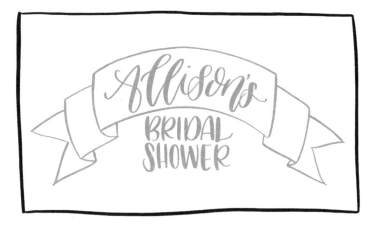

tip

Don't waste powder. Use a scrap paper to catch the powder knocked loose from your design before it's cured. Pull the paper ends toward the middle and create a light crease/funnel, then pour the powder back into its container.

Step 3

While holding the heat tool about 1½ inches away from your piece, you will see the powder curing. This will be obvious because you will notice changes in color, shine, sparkle, and texture. As you see the first part lift, "chase" the embossing by holding the heat tool at an angle and move it across the design and it will lift as you go. Once all of the powder has been cured, you are finished! Some powder will stick, just use a coarse, dry paintbrush to sweep it away. It's that quick and easy.

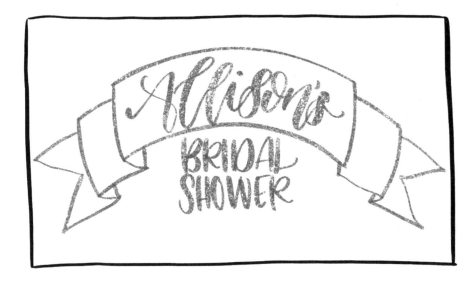

tip

Going over a design two to three times will make it extra raised. Pretty cool.

Common Uh-ohs and Fixes

My paper curls or warps: Turn the paper over and heat the back side. Depending on the thickness of the cardstock, this may need to be done several times.

The powder or paper burns: Move the tool as soon as you see the powder cure. Maintain a distance of about 1½ inches between the paper and heat tool.

I'm all done, but the embossing is uneven: This can occur if the ink wasn't wet enough when the powder was applied. Fear not—this is an easy fix! Just repeat the process over the areas that need it.

There is powder everywhere after embossing: Loose powder will try to stick on your project like crumbs—where you don't want it! Turn your paper over and lightly tap or flick the back side or use a course, dry paintbrush and a light sweeping motion to dust off the loose powder.

Variations

Combinations can be challenged by exciting, new ideas. For example, ideas include:

- black on black
- white on white
- clear only for texture effect and watercolor resistance
- orange on pink, red on blue, yellow on green, etc.

There are a variety of materials that can be embossed such as the following:

- paper
- vellum
- envelopes
- notebooks
- terra-cotta
- ceramic
- wood
- glass

envelope design

Envelope design can be so much fun. Remember that guidelines are your friend, and envelope design is where they really come in handy. You can use a ruler and light pencil line to mark where you want your guidelines. Use the following examples for some inspiration.

Example 1

Simple lettering with a long, edge-to-edge name line.

Mr & Mrs Blanchard
123 Main Street
City, State
1 2 3 4 5

Envelopes get fancy

Example 2

Use a pencil to create an arched guideline for the name.

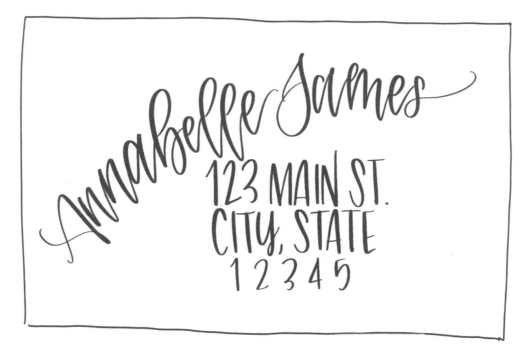

Example 3

Enclose the name and address in a banner.

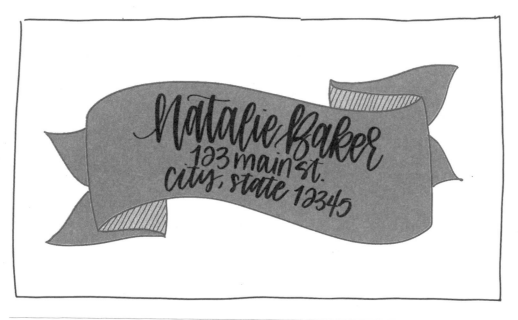

Example 4

Use a pencil to create a guideline to follow to vary the height of your letters.

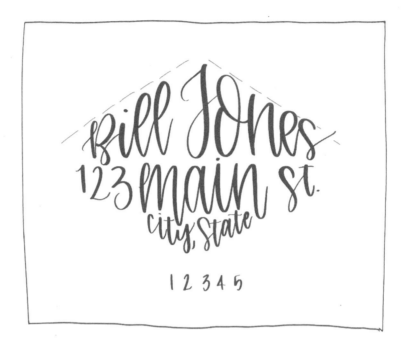

Example 5

Add a delivery instruction.

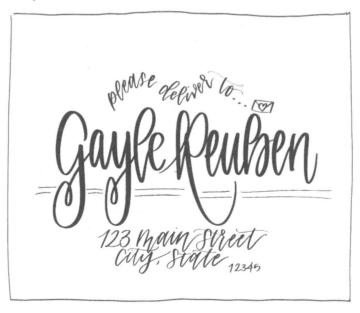

create a botanical alphabet using faux calligraphy

Let's get you familiar with some very easy, interchangeable floral doodles. Grab a piece of paper and follow along!

MATERIALS

- Quality paper
- Pencil
- Pen

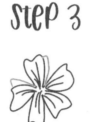
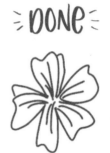

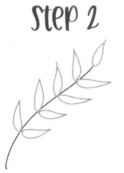
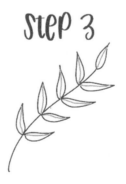

Step 1 Step 2 Step 3 DONE

Step 1 Step 2 Step 3 DONE

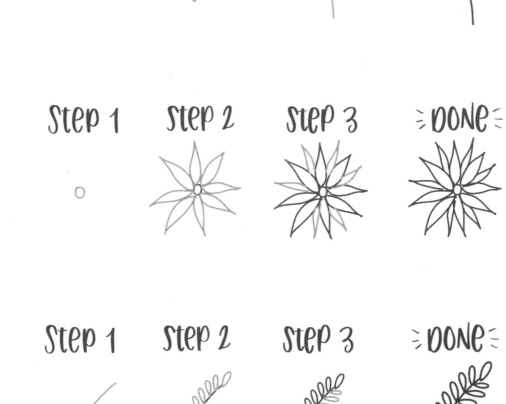

Step 1 Step 2 Step 3 ÷DONE÷

Step 1 step 2 step 3 ÷DONE÷

Step 1 step 2 step 3 ÷DONE÷

Step 1 Step 2 Step 3 ⟩DONE⟨

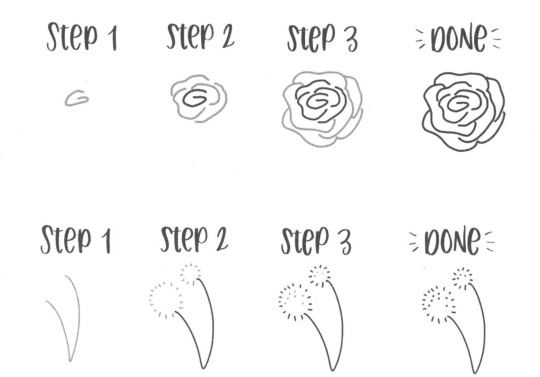

Step 1 Step 2 Step 3 ⟩DONE⟨

Step 1 Step 2 Step 3 ⟩DONE⟨

Step 1

Use a pencil to create your letters.

Step 2

Add flowers along one of the edges or in one isolated area in your letter's frame.

Step 3

Use ink over the pencil lines, but be careful not to go over the floral lines.

Step 4

Apply weight lines on the downstrokes, as covered in the faux calligraphy segment.
Again, don't draw through your flowers!

Step 5

Erase your pencil lines.

All done! You can keep your design as is, or you can add patterns or color to the white space inside the weight lines.

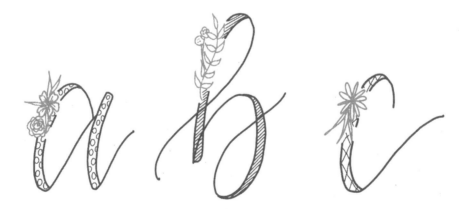

banner design

Banners make for the perfect illustrated touch when adding them to your lettering pieces. They create statements and can be used in a number of ways including envelope addressing, logos, slogans, labels, greeting cards, and so much more. Banner designs vary from simple, basic styles to more ornate, flowing flags.

The following pages show some basic banners to get you started.

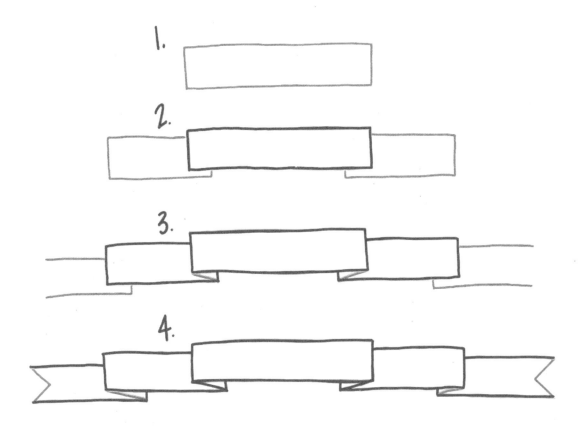

1.

2.

3.

4.

1.

2.

3.

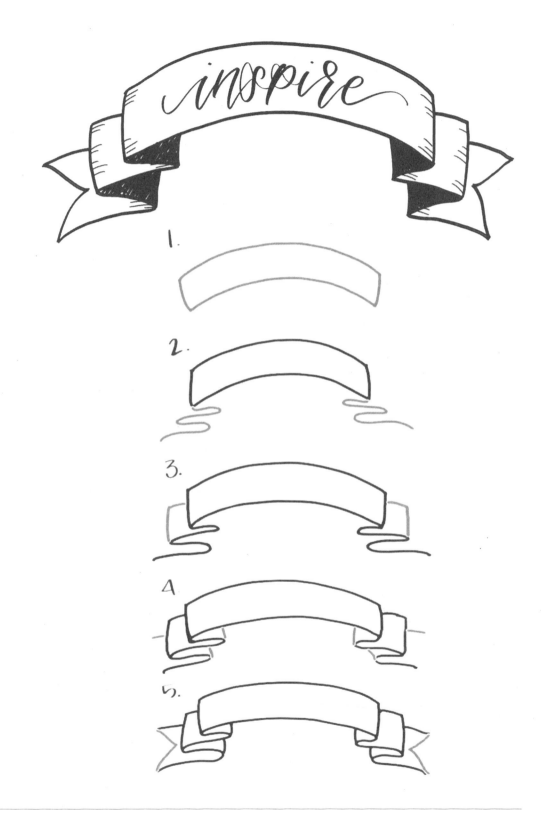

1.

2.

3.

4

5.

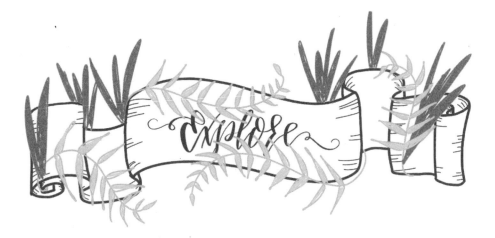

1.

2.

3.

4.

5.

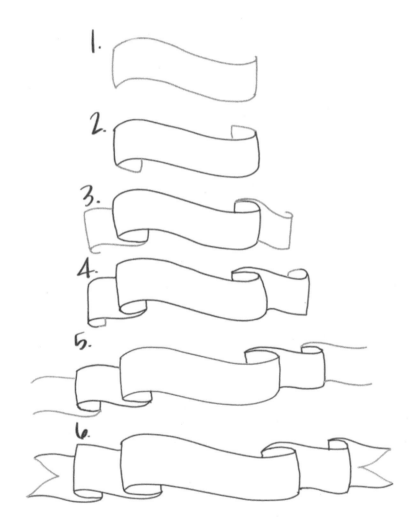

1.

2.

3.

4.

5.

6.

photograph and share your work

If you plan on taking photographs of your work, it's important to be aware of what's necessary to create high-quality images, but also where you can cut corners. The following is an easy, budget-friendly guide to assist the amateur photographer in creating eye-catching, swoon-worthy images. The best images will be crisp and clear with plenty of light. I've experimented with a ton of different ways to photograph my work. I've tried adding filters, fully digitizing it, and using props, and I've also experimented with so much lighting! The last thing you want is to have an amazing work of art, only to have it muted by dark lighting that doesn't showcase it in all of its glory. Also, when you set up to take pictures of your work, stay true to you! Don't compare your work to others. There is room for you! People want to see a reflection of you and your style because it's what makes you, you!

Lighting

Lighting is, hands down, the most important aspect in producing images of professional quality. If you've got your light source covered, the rest falls into place.

Best: Large windows that let in natural daylight

Good: Studio lighting (umbrella, softbox, ring light)

Okay: Daylight lightbulbs

Poor: Warm lighting (from regular house or apartment bulbs)

Camera

With technology's increasingly progressive design and functionality, a non-complex photo project no longer demands high-tech equipment.

Best: Digital SLR + photo editing software

Good: 2015+ Smartphone or digital camera

Poor: Disposable camera or webcam

tip

Use a flexible arm mount with a smartphone to capture video of your art process.

Photo Composition

Creativity has an opportunity to really shine here. Consider the following key points when capturing your images. What is the image going to be used for?

Photo Composition and Usage

	ANGLE	FRAMING	ACCENTS
Online Store	Head on	Perimeter, at a distance	Flowers, frame, colored or textured wall, trinkets
Social Media	Any! Low and flush, tilted, above, side, head on	Any! Low and flush, tilted, above, side, head on	Flowers, trinkets, nature, twine, coffee
Blog	Include multiple images to fully feature the piece in process	Include multiple images to fully feature the piece in different settings	Minimal, colored or textured walls, supplies
Portfolio	Head on	Perimeter	None
Prints	Head on	Perimeter	None

Enhance Your Photos

Applying edits digitally allows for additional lighting adjustments. Below are the main areas to focus on. It's amazing what a difference a small bump in brightness can do to liven up an image.

White Balance

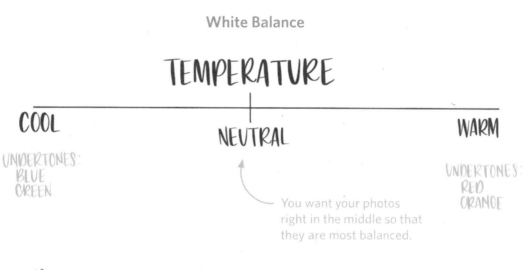

TEMPERATURE

COOL

NEUTRAL

WARM

UNDERTONES:
BLUE
GREEN

UNDERTONES:
RED
ORANGE

You want your photos right in the middle so that they are most balanced.

tip

Sometimes photos pick up a lot of warmth, so your photo will look neutral when it's adjusted more toward the cool side.

Brightness

+ 20%

How to Compose for Instagram

I absolutely love Instagram for its eye candy! You'll notice on my feed, @thepigeonletters, I'm constantly experimenting and changing how I present my work. I don't stick to a color scheme because I think it's much more fun to show multiple facets of my work. Don't get me wrong, however; if a color scheme makes you the happiest, then that will reflect in your work and that's what people want to see!

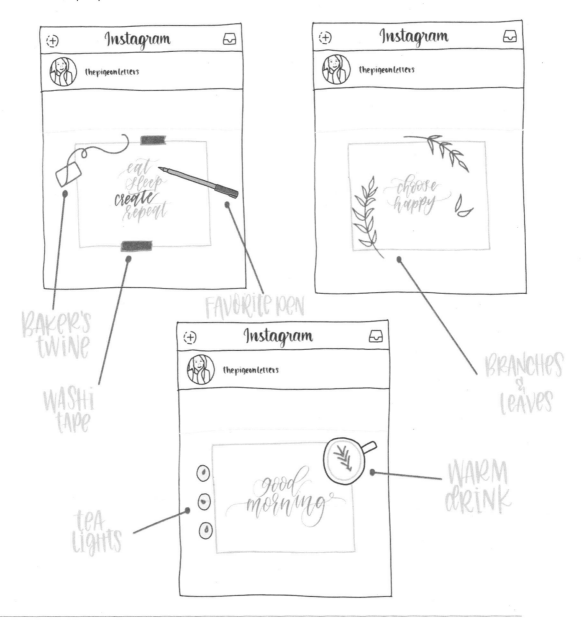

Common Hashtags to Keep on Your Radar

Hashtags are a way to organize photos on social media. If you include a hashtag on your post, it's like adding a category to your photo. It will automatically show up with other photos that use the same tag. Check out the following:

#moderncalligraphy

#brushlettering

#lettering

#handlettering

#modernscript

#handwrittenfont

#handdrawntype

#typographyinspired

#typematters

#pointedpen

#typespired

#calligrafriends

#artstagram

#qotd

#letteringchallenge

#thedailytype

#craftsposure

#goodtype

#letteringco

#calligraphymasters

#typeinspire

#dslettering

#typegang

#makersvillage

#creatorslane

#handletteredabcs

#calligrabasics

#learnlettering

#learncalligraphy

conclusion

Look at how far you've come! You've jumped into lettering and are now in full swing and ready to create projects of your very own with your newfound knowledge in base shapes, fundamentals of balance and weight lines, brush pens, bounce lettering, and additional enhancements to make your letters pop. Not only that, but you've dabbled in adding in some special effects to take your work to the next level. You're basically a pro. Thank you for choosing to include this book as part of your journey.

now go letter some pretties

further reading

ONLINE WATCH-AT-YOUR LEISURE COURSES
(MY CLASSES CHANNEL)
skillshare.com/r/thepigeonletters

NOTEWORTHY BLOGS

thepigeonletters WWW.THEPIGEONLETTERS.COM

tombow WWW.BLOG.TOMBOWUSA.COM

the inky hand WWW.THEINKYHAND.COM
↳ lefties!

shop

WWW.THEPIGEONLETTERS.ETSY.COM

 YOUTUBE.COM/C/THEPIGEONLETTERS

@thepigeonletters

acknowledgments

First, I want to thank the amazing art community that exists on many social media platforms. Social media has allowed connections like never before, and I'm thrilled that so many of you have chosen to have me as part of your learning journey.

I'd like to thank my wife, Laura Dean. Without her, I would have never taken the incredibly scary leap into what is now such a rewarding career by doing what I love every single day.

I want to thank the team at Skillshare for opening the first door for me. I've always been passionate about teaching, and teaching on a platform that values keeping creativity accessible is my jam.

I want to thank my agent, Carrie Howland, for convincing me that I could be bigger than the box I didn't realize I was trying to keep myself inside of.

Lastly, I want to thank the team at Ten Speed Press for being such a staple in building my book into something even greater than I envisioned.

Thank you, thank you, thank you.

about the author

Peggy is a self-taught artist who is proud to offer a non-conventional method of accessible education to anyone who wants to thrive in the art scene. She believes that more than anything art is about empowering oneself and being proud of something you've created with your hands. She is an award-winning educator, and her unique approach has landed her an interview on the *Today Show*, amongst several other news outlets. Living her passion has allowed her to spend more time with her family in the Pacific Northwest, surrounded by the most beautiful nature in the world.

index

alphabet
 botanical, 131–36
 styles, 59–71
ascenders, 22, 80

banner design, 137–42
baseline, 22
bounce, 21, 75–77
brush pens
 learning to use, 48–51
 types of, 14
bunting, 114–16

calligraphy
 characteristics of, 11
 definition of, 9
 faux, 41–45, 131–36
 history of, 9
 lettering vs., 8, 11, 23
 process of, 10
 tools for, 10, 11
 uses for, 10, 11
cap height, 22
collaboration, 4
composition, 105–10
crossbars, 21, 78

descenders, 22, 80, 90
downstrokes, 20, 41, 49

embossing, 123–27
entry strokes, 50
envelope design, 128–30
exit strokes, 20, 36, 88

faux calligraphy, 41–45, 131–36
fine tip pens, 15
flourishes, 20, 21, 94–6, 99–103

guidelines, 22–23

hairline strokes, 20, 93
hand guards, 57
hashtags, 147
head, 20

imperfections, value of, 2
inspiration, sources of, 3, 113
Instagram, 113, 146

lead-in strokes, 20, 36
left-handed letterers, 57
lettering
 calligraphy vs., 8, 11, 23
 characteristics of, 8, 11
 process of, 9
 terms for, 19–21
 tools for, 9, 11, 13–17
 typography vs., 10, 11
 uses for, 7, 9, 11
letters
 formation of, 30–35
 strokes in, 55
 styles for, 58–71, 85, 91
 See also alphabet
ligatures, 21, 97–98

mean line, 22
moods, 21, 82–83

networking, 4
numbers, 72–73

paper, 16–17
photographs, 143–47
Pinterest, 113
place cards, watercolor, 117–19
practice sheets, 24–29

resources, 4, 149
Rhodia pads, 16
roadblocks, avoiding, 3, 57

serifs, 21, 78
shoulder, 20
silhouette word collage, 120–22
stem, 20
strokes
 basic, 49–54
 in letters, 55
 See also individual strokes
swashes, 21, 78–79, 87

tail, 20
tools, 9, 11, 13–17
touch points, 30, 32
typography
 characteristics of, 10, 11
 definition of, 10
 lettering vs., 10, 11
 process of, 11
 tools for, 11
 uses for, 11

understrokes, 92
upstrokes, 20, 41, 49

variety, practicing, 85–93

watercolor paper, 17
weight, adding, 41–43
word collage, silhouette, 120–22
words
 made-up, 81
 practicing, 39–40
 rules for making, 37–38

x-height, 22